HOCKEY'S GREATEST PHOTOS

THE BRUCE BENNETT COLLECTION

EXCLUSIVE DISTRIBUTOR :
For Canada and the United States :
Simon & Schuster Canada
166 King Street East, Suite 300
Toronto, ON M5A 1J3
Phone : (647) 427-8882
1-800-387-0446
Fax : (647) 430-9446
simonandschuster.ca

Art Direction & Design: Erika Vanderveer

Project Editor: Ronnie Shuker
Fact-checker: Rachel Villari

Front Cover Information: Wayne Gretzky, 1979
Back Cover Information: New York Islanders, Nassau Coliseum, New York. April 19, 2015.

Catalogue data available from Bibliothèque et Archives nationales du Québec

08-15
© 2015, Juniper Publishing,
division of the Sogides Group Inc.,
a subsidiary of Québecor Média Inc.
(Montreal, Quebec)

Printed by Imprimerie Transcontinental, Beauceville, Canada
All rights reserved

Legal deposit: 2015
National Library of Québec
National Library of Canada

ISBN 978-1-988002-12-5

NHL, National Hockey League, image of the Stanley Cup and NHL team marks and related trade-marks are the registered trademarks of the National Hockey League and the teams and the reference to these marks are for identification only and is not authorized by or associated with the trade-mark owners.

Reference herein to the National Hockey League or any other organization does not constitute or imply endorsement by them of the content of this book. The views and opinions of the authors or of other individual expressed in the book do not reflect those of the National Hockey League or any other organization.

Conseil des Arts du Canada / Canada Council for the Arts

We gratefully acknowledge the support of the Canada Council for the Arts for its publishing program.

We acknowledge the financial support of the Government of Canada through the Canada Book Fund for our publishing activities.

The Hockey News

Presents

HOCKEY'S GREATEST PHOTOS

THE BRUCE BENNETT COLLECTION

FOREWORDS BY
WAYNE GRETZKY & MARTIN BRODEUR

JUNIPER PUBLISHING
A Quebecor Media Corporation

THN PRESENTS

HOCKEY'S GREATEST PHOTOS: THE BRUCE BENNETT COLLECTION

It's fitting that The Great One wrote the foreword to this book. After all, Bruce Bennett is the Wayne Gretzky of hockey photography. Although he's taken more than two million shots without scoring a goal, his stats tell the story of an all-time great behind the lens:

4,376	Regular season/playoff games
275	Pre-season games
26	All-Star Games
35	Stanley Cup deciding games
1	Winter Classic
4,678	TOTAL NHL GAMES

197	International tours, tournaments, exhibitions
180	Winter Olympic games
8	WHA games
22	Old-timers & Masters games
50	Minors, Juniors & College games
40	Seasons
52	Arenas shot in for NHL regular season games
34	NHL drafts
1	Memorial Cup
5,136	TOTAL GAMES (as of July 1, 2015)

In the mid-1970s, a tiny high school kid with wavy black hair approached us about buying some hockey photos he'd taken. Little did we know he'd go on to become one of the sport's best shooters and that he'd be recognized as the Einstein of hockey photography, as much for his wild gray mane as his genius behind the lens. We're glad we bought those images. It was the beginning of a four-decades long relationship that continues to this day.

Hockey's Greatest Photos commemorates 246 of Bruce's best photos taken over his 40-plus years chronicling the game, many of which came during his time as team photographer for the Islanders, Flyers, Rangers and Devils. Some of them are of historic moments, while others are immortalized images of hockey's superstars. But most are just flat-out cool photos of the world's greatest game (a few lucky shots are included as well). Every one of them captures something unique about the sport across a wide range of emotions – from the glory of victory to the agony of defeat.

Wherever possible, we've included the name(s), place and (approximate) date for every shot, as well as a little description when necessary. In images with multiple prominent faces, people are listed left to right.

For the most part, we let the photos do the talking, but whenever Bruce ("BB") had a behind-the-lens story to tell, we included a brief write-up from him to accompany the image.

They say a picture is worth a thousand words. As such, what follows, in relatively random order, is Bruce Bennett's 246,000-word photo essay. So let the hits begin…

PHOTO BY ANDY MARLIN

"YOU MISS 100% OF THE SHOTS YOU DON'T TAKE"
– WAYNE GRETZKY

"DITTO"
– BRUCE BENNETT

THE FOREWORD

BY WAYNE GRETZKY

The first time I got to know Bruce was at the 1982 All-Star Game on Long Island. In those days, there wasn't a skills competition, and all that, but we used to have a charity dinner and a black tie event, and Bruce would always take the pictures. He always got a picture taken with a certain player or a couple different guys from other teams, and the next year at the All-Star Game he would hand you the pictures he'd taken. He was very reliable.

Over the years, Bruce and I have become friends. Back in those days, it really wasn't uncommon for the players to have dinner or a beer with photographers or reporters. It wasn't as guarded as it is today in the sense there's a separation between the athletes and the media. It's a different era now: we didn't have Twitter, Facebook or cellphones for most of my career. There was a respect factor between players and media. We understood they had a responsibility to cover the team and the game, and yet we also understood they were people, too. They were the link between the locker room and the rink for the fans. We just took them as part of the group. It wasn't even an issue. They were all part of the hockey team itself.

If I had to describe Bruce with one word, it'd be "professionalism." He's as respected as anybody in the industry. He's the kind of guy that gets all the pictures done and everything you need without being in the way. He's got an uncanny sense for staying out of the middle of everything and getting the pictures he needs to get to make the event so much better. I was always comfortable with him, and he always took great pictures. He's a good person who really enjoys the game of hockey and loves participating as much as the guys having their pictures taken. He never steps on anyone's toes, never gets in the way and he understands that if something can't be done, there's a reason why. He's very accommodating, and that makes it so much easier for everyone. He knows the shots he wants to get taken and gets everything he needs to get done in a proper amount of time without dragging on and lasting forever. Most importantly, he picks the right pictures, and he always gets a picture that's going to withstand the test of time.

Many players look at old photos and videos, and I do too. I can't speak for everyone, but for me I enjoy looking back periodically. If something comes on TV, I'll put it on, or if there's a scrapbook, I'll look at it. I can look at photos from when I was eight, nine and 10 years old that my dad took, and I can say where it was, what year, what game – that's what keeps my memory alive of what I did in my younger days. They're keepsakes for me, and they're memories I'll always have. Whether they're from my last year in the NHL with New York or my first year in the WHA with Indianapolis, I truly enjoy looking at old photos – many of which Bruce took – and seeing the players in those photos that I played with and against. Bruce's images help me relive those moments.

One of those players is Mark Messier. It was always great playing with Mark, because we're good friends. He's a Hall of Famer and was a wonderful player, but more importantly he's a better person. When we won our first Stanley Cup, we were so young, and we thought we knew the whole world, though we were only 22 or 23 years old. It's a memory we'll never forget.

After I was traded to Los Angeles, the first game I played against him was tough for both of us. I always hated playing against Edmonton, and I make no secret about it. I really never got comfortable, and never really enjoyed playing in Edmonton against the Oilers. It's because of how good the organization was to me, how many good friends I had on that team, the success we had and how great the fans treated me – not just in the arena but as a person around the city.

Mark was the best player I ever played with, but Mario Lemieux was the best player I ever played against. I was lucky enough to play with him at the 1987 Canada Cup. About three quarters through the tournament, the coaching staff put him and I together. It was really like magic. We just clicked together. We thought the game the same way, and we both played unselfishly. Our responsibility was to get the puck to the net, and it didn't matter which one of us was going to score. It was just a pleasure to play with one of the greatest players that ever lived, because he was such a pure talent. His talent and his ability spoke for themselves.

The greatest player ever, though, was Gordie Howe. He's a pretty remarkable man. When you grow up idolizing somebody, sometimes that person isn't as nice as you had pictured him or suited to the pedestal you put him on. I met Gordie when I was 10, and we became friends. He was bigger and better and nicer than I'd ever imagined when I was eight years old writing a book report about him. I was truly blessed that over the years I developed a friendship and a relationship with not only him but his family, too.

When I was closing in on his record for most career points, Gordie and his wife called me and told me he wanted to be there and be part of it. They were in L.A. for a little bit and travelled with the team. Then they flew into Vancouver and Edmonton, and all I kept saying to my dad was, "I sure hope I do this quickly so Gordie can get on with his life." It was always a reminder to me that the best player in the game thought the game was bigger than any one person, and for him to be there is something I'll always remember.

Bruce was excited to be part of it, too. Nobody was as excited as Bruce, who was there to shoot the game. Between Bruce, my dad, Gordie, Janet and myself, we were all amazed that, through all the games I'd played, this record would happen in Edmonton. It was a pretty unique moment for me, and one I'll never forget.

Throughout my career, Bruce has been there to shoot so many of my most memorable moments. When we saw him around the arena, we always knew it was a big game if Bruce was there, especially when I was playing in Edmonton. Whenever we saw him at the game we always said, "This is a big game on *Hockey Night in Canada* and Bruce Bennett is here."

One of the biggest games was the last one I ever played. I had spent some time thinking about what the game was going to be like. I really prolonged the day in the sense that I knew it was my last time there and my last time in the arena, and I wasn't going to be the guy a year later saying, "I'm going to try and come back and play one more year." I knew that when I was done, I was done. I just really wanted to take it all in from every aspect, including getting pictures by myself, pictures with my family and pictures with my teammates. It turned out to be a pretty special day for me, and Bruce played a big part in capturing that.

I continue to work with Bruce to this very day. Every year, he helps out at my fantasy hockey camp, taking pictures for all the young kids. Whether it's shooting the kids camp or a Stanley Cup final, his professionalism and love for hockey always shine through. And his eye for immortalizing memorable moments of the game have made him one of the best ever behind the lens.

May 19, 1984 ▸

THE BIG PICTURE

BY MARTIN BRODEUR

Certain pictures mean a lot to me, many of which Bruce took, especially ones of the records I set and the Stanley Cups I won. I've been lucky enough to accomplish a lot in this league, and I should be proud of it. Now that my playing career is over, I'm able to relive many of those moments thanks to Bruce's photos.

During my playing days, I always paid special attention to photographers. I had to, actually, because they were occasionally an occupational hazard. There are holes in the glass for cameras, and it was important for me to know where they were. If there was a dump-in, the puck could've hit the camera and taken a crazy bounce, so that was something I always looked for wherever I played.

But that wasn't the main reason. It was natural for me to look around for photographers, because I've always had a great deal of respect for them. My dad, Denis, was the Montreal Canadiens' team photographer for many years, and I got the chance to go to a lot of games with him, especially on the weekends. He'd get me one of those little round seats they used to have in the first row at The Forum, and he'd be on one side shooting the game, while I'd be on the other…taking pictures of goalies, of course.

When I was younger, I had three pictures on my wall: Sean Burke, Kirk McLean and Ron Hextall. Those were the goalies I admired most when I was growing up, and my dad had taken photos of all three. When I was about 15 or 16 years old, I asked him if he could print those pictures for me and put them on my wall. I looked at them all the time, because they were the type of goalie I wanted to be.

Having a hockey photographer for a father meant I was pretty lucky as a kid. Many times, I'd get to go to the rink with my dad for private photo shoots with superstars like Patrick Roy or Guy Lafleur. That was just golden for me. My friends were going nuts, because I had access to all this stuff that was almost impossible for other kids.

There was one photo shoot my father had with Patrick after his rookie season. He was sitting there talking to Patrick and saying, "You'll see my son one day. He's going to play in the NHL." Patrick was just like, "Yeah, yeah, yeah." And then years later, we ended up being teammates and challenging for the same goals at the end of our careers, which is kind of funny.

One of the first things I remember when I think about Bruce is the respect my father had for him. That's why I always took time to say hello and talk to him whenever we saw each other. He covered my entire career and immortalized some of my biggest accomplishments. He captured many milestones, including my 552nd win to set the all-time wins record for goalies. And he was there for all three Stanley Cups I won, including my first in 1995 when he took a picture of my dad and me in the dressing room celebrating together afterward (pg. 47). These are memories I cherish through his photos.

Bruce and I sometimes sat beside each other during games at the Continental Airlines Arena in New Jersey. The photographer's box was right beside where the Devils' backup goalie sat, so whenever I wasn't starting, we'd talk and joke around. I'd tell him, "Don't take too many pictures, I'm changing my equipment next week," and stuff like that.

Like any hockey fan, I enjoy watching videos, but with pictures you get a thousand words. Whenever I look at a shot of the game in Montreal when I tied Patrick for the wins record or in New Jersey against Chicago when I beat the record, it takes me back to that time. There are photos of me taking it all in – cutting the net, skating around and waving at the crowd. There are videos, too, but pictures are great to look at because they capture the essence of moments like that.

When I look at pictures of me, most of the time I look at my eyes to see if I'm looking at the puck or not. The puck might be hitting me in the shoulder, and I'll be looking somewhere else, so when I look at some photos now, I laugh and think, "What am I doing?" That's something you can't see in videos.

With photography, however, it can catch you right as you're making a save. You can see the impact of the puck and what it does to your equipment. Those split second photographs are part of what hockey photography is all about.

The other part is the moments frozen in time. My dad took the famous picture of Paul Henderson scor-

ing the winning goal in the 1972 Summit Series, and I own that now. He tried to sell it once, but I said, "You don't sell that. This is the best picture you ever took." Pictures like that show joy and sadness in the same photo. When Henderson scores, you can see all the Soviets down on the ice or hanging their heads. It gives you a good perspective on the happiness of one team and the heartache of the other.

Bruce took a similar photo from Game 6 of the 2012 Eastern Conference final. Adam Henrique scored in overtime to beat the New York Rangers and send us to the Stanley Cup final (pg. 211). You can see the happiness on Adam's face contrasted with the sadness of the body language written all over Henrik Lundqvist and the Rangers players – they know it's over for them.

Many of Bruce's photos capture that elation and dejection together. There's a reason why Bruce has shot more than 5,000 games and been around for more than 40 years. He's one of the best ever at what he does.

People should understand his commitment to the game and the respect he has for the players he photographs. He's such a class act, and he's so well known and respected among players. Not every photographer can connect with players during their careers, but he has done that with me because of my dad. He's somebody I have a lot of respect for because of my background.

Prudential Center, New Jersey. March 28, 2009

▸

◄

HENRIK LUNDQVIST

*Madison Square Garden,
New York.
April 4, 2011.*

▶

**DION PHANEUF
& MICHAEL SAUER**

*Madison Square Garden,
New York.
December 5, 2011.*

> ### SIDNEY CROSBY

Crosby's 100th point as a rookie.

*Mellon Arena, Pittsburgh.
April 17, 2006.*

> ### ZENON KONOPKA

*Nassau Coliseum, New York.
October 29, 2010.*

RICK MIDDLETON & RAY BOURQUE

*Boston Garden,
Boston.
October 1981.*

DENIS POTVIN

With Jean Potvin, Clark Gillies and Bryan Trottier.

*Nassau Coliseum,
New York.
1975.*

STEVE YZERMAN

*Nassau Coliseum,
New York.
January 1984.*

> **STEVE YZERMAN**

No longer a pretty boy, 'Stevie Y' embraces his first Stanley Cup at 32 years old, more than a decade after he broke into the NHL as an 18-year-old baby-faced rookie who idolized Gordie Howe.

Joe Louis Arena, Detroit. June 7, 1997.

◂

**MATT READ &
MARCUS JOHANSSON**

*Wells Fargo Center,
Philadelphia.
March 22, 2012.*

▸

**SIDNEY CROSBY
& EVGENI MALKIN**

BB: "This was taken by a camera with a fish-eye lens and an enclosure that we normally use in the net. For this shot, we put it inside the bench, and I shot blindly throughout the game hoping for a usable image."

*Nassau Coliseum,
New York.
March 29, 2012.*

◄

JACK HILLEN & BRANDON PRUST

*Nassau Coliseum, New York.
March 31, 2011.*

►

CHRIS CHELIOS & NICKLAS LIDSTROM

Two Hall of Fame defensemen celebrate their third and fourth Stanley Cups, respectively.

*Mellon Arena, Pittsburgh.
June 4, 2008.*

JAROSLAV HALAK

BB: "A slower shutter speed accentuates the swirl of activity around the prone goaltender."

*Nassau Coliseum,
New York.
March 24, 2015.*

WALTER & WAYNE GRETZKY

BB: "This was taken during the morning skate before the All-Star Game. Walter was there, and he was leaning on the bench, so I just lined up the shot with Wayne.

"Walter is such a remarkable human being. You can see where Wayne gets his attitude toward people. His humility and his sense of humor – it all comes from Walter. I once flew up to Toronto and drove out to Brantford, Ont., to photograph Walter and also Wayne's brothers – Glen, Keith and Brent – at home. He made me a tuna fish sandwich, which I hate, but it would've been impolite to refuse it. Walter was as hospitable as you could be to somebody you didn't know. It just didn't matter, that's Walter."

*Brendan Byrne Arena,
New Jersey.
January 31, 1984.*

PETER FORSBERG

BB: "The image most people are familiar with is Forsberg's crazy deke to win the gold medal for Sweden at the Lillehammer Games. I was there shooting every game I could get to. In the men's gold medal game, it got down to that final shootout attempt, but I shot very few photos of it. I had it stuck in my head from years of shooting that I shouldn't waste film because of the cost. The film and the processing at the Olympics were free, but old habits die hard. I still had a few frames left on that roll of film, however, so I was able to come up with this one of him celebrating."

Lillehammer, Norway.
February 27, 1994.

CAMMI GRANATO

Granato celebrates Team USA's gold medal win over Canada at the Winter Olympics.

Nagano, Japan.
February 17, 1998.

◂

SIDNEY CROSBY

'Sid The Kid' celebrates his
Stanley Cup win with
his father, Troy.

*Joe Louis Arena,
Detroit.
June 12, 2009.*

▸

ANTERO NIITTYMAKI

*Wachovia Center,
Philadelphia.
October 13, 2007.*

MIKE BOSSY

Commemorating one of his 50-goal seasons.

Nassau Coliseum, New York.

HERB BROOKS & CRAIG PATRICK

The architects of the 'Miracle on Ice' come together as the Rangers' coach and GM, respectively.

Madison Square Garden, New York.
1981.

BRIAN LEETCH

BB: "For this photo, I got the scoreboard lowered at MSG and had Leetch's name put up there. I thought it was a cool background for him. It's one of these things where you get access to a player and then go, 'Oh boy, what am I going to do with him? What am I going to do that's different? How is it going to be lit?' I don't remember when I got the idea to have the scoreboard brought down, but it ended up being a decent shot."

Madison Square Garden, New York.
1990s.

RILEY COTE & ERIC GODARD

Mellon Arena, Pittsburgh.
December 15, 2009.

31

TEAM FINLAND

Winter Olympics.

*Bolshoy Ice Dome,
Sochi, Russia.
February 14, 2014.*

U.S. WOMEN'S TEAM

Kacey Bellamy, Amanda Kessel, Kelli Stack, Megan Bozek, Hilary Knight, Michelle Picard and Kendall Coyne at the Winter Olympics.

*Bolshoy Ice Dome,
Sochi, Russia.
February 17, 2014.*

THE GREAT ONE

BB: "Wayne had already played his final game in Canada two days earlier in Ottawa, so the build up for his last game ever was incredible and the atmosphere in MSG was electric. Most players tune that out when they're on the ice, so I'm not sure Wayne was able to stop, pause and think about the moment until it was over. The day before, I did a photo shoot with him at the team's practice facility in Rye, N.Y., where we took some portrait shots with his skates. Wayne was just taking it all in stride. He was comfortable with his decision, and when you're comfortable with a decision like that it makes it that much easier to step away from the sport.

"I was the Rangers' team photographer at the time, and in the dressing room afterward we had two photographers shooting Wayne hanging up his skates for the last time. The team sealed the room before the end of the game to maintain order, so I had to put my photographers in there before Wayne skated around the ice and had his farewells. During his whole thing on the ice, they were stuck in the room, so I didn't have them for the end of the game, but we had staffed the game with enough photographers that we could sacrifice two of them to be in there for that final moment. The Rangers are a first-class organization. It doesn't matter how many photographers are needed to get the job done. They have an understanding that once a moment in history has passed unrecorded, you've lost it. So if you haven't documented it correctly, archived the images properly and saved everything, then that moment is gone forever."

*Madison Square Garden,
New York.
April 18, 1999.*

WAYNE GRETZKY

*Rye, N.Y.
April 17, 1999.*

◄

WAYNE GRETZKY

*Madison Square Garden,
New York.
April 18, 1999.*

▶

STEPHANE MATTEAU

Matteau's overtime goal in Game 7 for the Rangers eliminates the Devils in the Eastern Conference final.

*Madison Square Garden,
New York.
May 27, 1994.*

CHRIS DRURY

*Mellon Arena, Pittsburgh.
May 4, 2008.*

BOBBY & BRETT HULL

Father and son celebrate Brett's Hart Trophy win at the NHL Awards in Toronto.

June 7, 1991.

◂

CROWDED CREASE

Brian Elliott, Carl Gunnarsson, Kevin Shattenkirk, Joakim Lindstrom and Jaden Schwartz.

Madison Square Garden, New York. November 3, 2014.

▸

GUY LAFLEUR

Madison Square Garden, New York.

PARTY TIME

The Red Wings leave it all on the ice after beating the Hurricanes to win the Stanley Cup.

*Joe Louis Arena,
Detroit.
June 13, 2002.*

NICKLAS LIDSTROM

Lidstrom's son sits perched above his father's stall beside the Conn Smythe Trophy his dad won as playoff MVP.

*Joe Louis Arena,
Detroit.
June 13, 2002.*

44

◄

BRYAN TROTTIER

Stanley Cup final.

*Nassau Coliseum,
New York.
May 1982.*

▶

BRENDAN SHANAHAN

Celebrating his 600th NHL goal.

*Madison Square Garden,
New York.
October 5, 2006.*

BILLY SMITH & WAYNE GRETZKY

*Nassau Coliseum,
New York.
1984.*

DENIS & MARTIN BRODEUR

BB: "This shot of Brodeur's first Stanley Cup means a lot to me. His father, Denis, was the Canadiens' team photographer, and I got to know him well until he passed away in 2014. I first met him when he was covering the 1976 Summer Olympics in Montreal, and we became friends on my frequent visits to The Forum to shoot games. When I was the Devils' team photographer from 1995 to 2004, I always looked forward to his visits to New Jersey where he'd photograph Martin. I'd hang out in the pressroom with Denis, and we'd talk about hockey and photography."

*Brendan Byrne Arena,
New Jersey.
June 24, 1995.*

STEVE YZERMAN

BB: "I loved the old photo boxes at Nassau Coliseum right next to the penalty boxes. There was no glass barrier at all. That was my treasured spot. You could nail all the visiting players when they came to town. It kept you in the game, because you never knew if you were going to get hit by a player, a puck or a stick. And if you were falling asleep, the peppermint smell of liniment from the creams players used for muscle aches and pains would smack you in the face as the players rushed by."

*Nassau Coliseum,
New York.
1984.*

STEVEN STAMKOS

Eastern Conference final
Game 5.

*Madison Square Garden,
New York.
May 24, 2015.*

CHARLIE SIMMER, MARCEL DIONNE & DAVE TAYLOR

The Kings' famed 'Triple Crown Line.'

*Nassau Coliseum,
New York.
April 1980.*

HENRIK LUNDQVIST & ALEX OVECHKIN

Atlantic Division final Game 2.

*Madison Square Garden,
New York.
May 2, 2015.*

◄

WAYNE GRETZKY

*Jobing.com Arena,
Arizona.
February 28, 2009.*

►

TEEMU SELANNE

*Wachovia Center,
Philadelphia.
October 10, 2009.*

MARK MESSIER

BB: "In hockey photography, the most important feature is the eyes, and Messier most definitely had the eyes. When you get a player who's that passionate and motivated, it always leads to good photos. This image shows what a warrior Messier was and how intense he was."

LUC ROBITAILLE & JAROMIR JAGR

A pair of Penguins superstar wingers goof around during a photo shoot for The Hockey News.

February 1995.

JOHN MCKENZIE

The New England Whalers of the World Hockey Association.

Hartford, Conn.
1979.

LORNE HENNING, BOBBY NYSTROM, MEL BRIDGMAN & BOB DAILEY

BB: "This has a special place in my heart, because I was brought up on Long Island. I was sitting near center ice when Nystrom scored the winning goal in overtime to give the Islanders their first Stanley Cup in franchise history. I just pounded off a few photos then jumped over the boards and photographed the celebration afterward. I was a Rangers fan growing up because the Islanders didn't show up until 1972, but the Isles eventually became my favorite because I'm a Long Islander at heart."

Nassau Coliseum,
New York.
May 24, 1980.

MATT MOULSON

*Nassau Coliseum,
New York.
November 27, 2009.*

EVGENI MALKIN

*Air Canada Centre,
Toronto.
November 14, 2014.*

◄

VLADISLAV TRETIAK & JIM CRAIG

BB: "Both of these images were shot at an exhibition game prior to the 1980 Winter Olympics. The Soviets won that game easily, beating the Americans 10-3. Hindsight is 20/20, but I didn't go to the Lake Placid Games. I figured it was just a bunch of kids going up against the high-powered Red Army team, and I didn't really know what kind of market I would have for those photos. Part of it was not thinking ahead and part of it was probably not being able to get credentials to go photograph the event. But the amount of sales I've had on images from that game at MSG, well, it's probably one of the hottest exhibition games I've ever shot."

*Madison Square Garden,
New York.
February 9, 1980.*

►

MIKE ERUZIONE

*Madison Square Garden,
New York.
February 9, 1980.*

CHRIS PRONGER & MARK RECCHI

Stanley Cup final Game 7.

*RBC Center,
Carolina.
June 19, 2006.*

RAFFI TORRES & ROD BRIND'AMOUR

Stanley Cup final Game 7.

*RBC Center,
Carolina.
June 19, 2006.*

◀

RAY EMERY & BRADEN HOLTBY

Wells Fargo Center, Philadelphia.
November 1, 2013.

▶

MARK MESSIER

'Moose' begins his NHL career as a fresh-faced 18-year-old with the Oilers.

Madison Square Garden, New York.
1979-80 Season.

GUY LAFLEUR & MIKE BOSSY

Two superstars show the sportsmanship of the game after the Islanders eliminate the Canadiens in the Wales Conference final.

Nassau Coliseum, New York.
May 5, 1984.

ALEX OVECHKIN & ZDENO CHARA

Captains meet in the middle after Russia beats Slovakia in overtime in the preliminary round at the Winter Olympics.

Bolshoy Ice Dome, Sochi, Russia.
February 16, 2014.

MARTIN BRODEUR

*Madison Square Garden,
New York.
April 16, 2008.*

**MIKE GARTNER &
DARIUS KASPARAITIS**

*Nassau Coliseum,
New York.
1993.*

REBECCA JOHNSTON, LAURA FORTINO & JENNIFER WAKEFIELD

Canada's golden girls celebrate their victory over the United States at the Winter Olympics.

Bolshoy Ice Dome, Sochi, Russia. February 20, 2014.

KELLI STACK, JOCELYNE LAMOUREUX & LYNDSEY FRY

There was no silver lining for the Americans after losing to the Canadians in the gold medal game.

Bolshoy Ice Dome, Sochi, Russia. February 20, 2014.

KEN DRYDEN

*Nassau Coliseum,
New York.
Late 1970s.*

MATTHEW BARNABY

BB: "Islanders-Rangers is such a great rivalry. The games are always intense, and the players feed off the fans. Here Barnaby is going after the Islanders fans after scoring a goal."

*Nassau Coliseum,
New York.
2003.*

◂

MIKE MILBURY

BB: "In this photo, the police are intervening during a brawl between the Bruins and Rangers that spilled into the stands, where Milbury clubbed a Blueshirts fan with his own shoe. I had packed three rolls of film for the game – one for each period – and when this happened late in the third, I only had a few frames left on my last roll."

Madison Square Garden,
New York.
December 23, 1979.

▸

MIKE BOSSY

Nassau Coliseum,
New York.
1985.

NICK KYPREOS & RYAN VANDENBUSSCHE

The fight that ended Kypreos' career.

Madison Square Garden, New York.
September 15, 1997.

MARTIN GRENIER & PETTERI NOKELAINEN

Nassau Coliseum, New York.
September 20, 2005.

◂ CLARK GILLIES, BRYAN TROTTIER & MIKE BOSSY

'The Trio Grande' line.

*Twin Rinks,
Farmingdale, N.Y.
March 1979.*

▴ HENRIK LUNDQVIST & ERIC BOULTON

BB: " 'King Henrik' appears to get all snowed in. Or is it fairy dust being cast from the referee's raised hand?"

*Madison Square Garden,
New York.
December 20, 2013.*

◀

USA HOCKEY POND HOCKEY CHAMPIONSHIP

BB: "It's difficult sometimes to shoot the same thing day-in and day-out, even when it's hockey. So you try to keep yourself fresh by finding different angles, using different lenses and standing in different places. During the 2012-13 lockout, I went looking for something to shoot and found this pond hockey tournament. Going to something like this, where there was natural light, I was like a kid in a candy store. Everywhere I turned, there was a photo opportunity that said 'hockey' in a much different way than I'd shot over the previous 30-something years. This was one of my favorites from the trip."

Eagle River, Wis.
February 9, 2013.

▶

WAYNE GRETZKY

The Forum,
Montreal.
January 9, 1985.

81

◄

WENDEL CLARK

*Nassau Coliseum,
New York.
1989.*

►

JORDAN STAAL

Stanley Cup final Game 4.

*Mellon Arena,
Pittsburgh.
June 4, 2009.*

◄

**NORDIQUES
VS. CANADIENS**

*The Forum,
Montreal.
1980s.*

►

DENIS POTVIN

BB: "Potvin, I love that guy. Here he's showing off his championship rings from his four straight Stanley Cups with the Islanders. His personality, attitude and warmth made him such a great guy to be around. One of the few weddings I photographed was his. As a sports specialist, I really knew nothing about photographing weddings, but it was an honor for me to do that for him."

*Nassau Coliseum,
New York.
2004.*

PATRICK ROY

'St. Patrick' celebrates his second Stanley Cup with the Canadiens.

The Forum, Montreal. June 9, 1993.

TIE DOMI & BOB PROBERT

Madison Square Garden, New York. February 9, 1992.

◄

**MARK MESSIER
& PHIL ESPOSITO**

One Hall of Fame career is just beginning as another is coming to its end.

*Madison Square Garden,
New York.
1979-80 Season.*

►

JOHN TAVARES

Celebrating his first NHL goal.

*Nassau Coliseum,
New York.
October 3, 2009.*

◄

**COREY HIRSCH
& MARIO LEMIEUX**

*Madison Square Garden,
New York.
1992-93 Season.*

►

**GORDIE HOWE
& PHIL ESPOSITO**

Aging legends face off
near the end of their
Hall of Fame careers.

*Madison Square Garden,
New York.
1980.*

**PHIL KESSEL
& SERGEI BOBROVSKY**

Winter Olympics.

*Bolshoy Ice Dome,
Sochi, Russia.
February 15, 2014.*

BOBBY RYAN

Winter Olympics.

*Canada Hockey Place,
Vancouver.
February 16, 2010.*

◁

MARIO LEMIEUX

Pittsburgh.
1988.

▷

DAN CLOUTIER
& TOMMY SALO

Nassau Coliseum,
New York.
April 4, 1998.

◄

LOS ANGELES KINGS

BB: "This is one of the 60 images I rattled off when Alec Martinez beat Henrik Lundqvist in double overtime of Game 5 to win the Stanley Cup. It was taken on a remote camera I had installed in the rafters. I triggered it from my spot in the Zamboni corner as I watched the closing minutes of the game on the scoreboard."

*Staples Center,
Los Angeles.
June 13, 2014.*

►

NEW YORK ISLANDERS

A photo shoot commemorating the Isles' four consecutive Stanley Cups in the early '80s.

*Nassau Coliseum,
New York.
1983.*

BOBBY HULL

'The Golden Jet' in full flight as a Winnipeg Jet.

*Madison Square Garden, New York.
November 21, 1979.*

WENDELL YOUNG & PAT LAFONTAINE

Nassau Coliseum, New York.

◂

**MARC &
JORDAN STAAL**

Brothers embrace after the Penguins eliminate the Rangers in Game 5 of the Eastern Conference semifinal.

*Mellon Arena, Pittsburgh.
May 4, 2008.*

▸

**MARK MESSIER
& WAYNE GRETZKY**

Stanley Cup final.

*Northlands Coliseum, Edmonton.
May 1988.*

101

BOBBY ORR

The heart and soul of the Black and Gold just doesn't look right in Black Hawks garb.

*Nassau Coliseum,
New York.
October 9, 1976.*

GLENN RESCH

*Nassau Coliseum,
New York.*

◂

STAN MIKITA

*Nassau Coliseum,
New York.
Late 1970s.*

▸

**MARTIN BRODEUR
& ERIC STAAL**

Eastern Conference
semifinal Game 5.

*RBC Center,
Carolina.
May 14, 2006.*

**CHRIS CHELIOS
& KARL STEWART**

*United Center,
Chicago.
November 2, 2006.*

BOBBY HOLIK

*Brendan Byrne Arena,
New Jersey.
June 24, 1995.*

SCOTT STEVENS & PAUL KARIYA

Kariya gets drilled by Stevens midway through Game 6 of the Stanley Cup final and knocked out of the contest. He comes back to score in the third period and force a deciding game, but the Mighty Ducks fall to the Devils in seven.

Arrowhead Pond, Anaheim.
June 7, 2003.

JOHN TONELLI

Tonelli scores in overtime as the Islanders eliminate the Penguins in Game 5 of the Patrick Division semifinal.

Nassau Coliseum, New York.
April 13, 1982.

110

◄

ALL-STAR OILERS

Andy Moog, Wayne Gretzky, Glenn Anderson, Paul Coffey, Kevin Lowe, Glen Sather, Mark Messier, Lee Fogolin, Jari Kurri and Grant Fuhr.

*Hartford Civic Center,
Hartford, Conn.
February 4, 1986.*

►

KEN 'THE RAT' LINSEMAN

*The Spectrum,
Philadelphia.
December 1980.*

DAVE TAYLOR, MARCEL DIONNE & CHARLIE SIMMER

The three Kings on L.A.'s 'Triple Crown Line'.

Hartford Civic Center, Hartford, Conn. January 14, 1981.

HENRIK LUNDQVIST

Nassau Coliseum, New York. April 3, 2008.

DENIS POTVIN & GUY LAFLEUR

BB: "Another one of my favorite images. It was shot on black and white film with an older, slower motor drive. I still ended up with a sequence of four frames, including the definitive Lafleur face-on-ice shot."

*Nassau Coliseum,
New York.
1983.*

NEW JERSEY DEVILS

*Prudential Center,
New Jersey.
October 29, 2008.*

◄

KURTIS FOSTER

BB: "Donating a gift to yours truly on Kimmo Timonen Day."

Wells Fargo Center, Philadelphia. March 26, 2013.

▶

ALEX OVECHKIN

NHL All-Star Skills Competition.

Philips Arena, Atlanta, Ga. January 26, 2008.

**COREY CRAWFORD
& MILAN LUCIC**

Stanley Cup final Game 1.

*United Center,
Chicago.
June 12, 2013.*

MARK MESSIER

*Madison Square Garden,
New York.
Early 1990s.*

◀

SCOTT STEVENS

Continental Airlines Arena, New Jersey.
2002-03 Season.

▶

PAT LAFONTAINE

LaFontaine celebrates after the United States beats Canada in Game 3 of the final to win the World Cup of Hockey.

The Forum,
Montreal.
September 14, 1996.

◄

MIKE BOSSY

BB: "This photo shoot was done in a small studio we assembled in the bowels of the arena. I'd practiced the technique at home, which was basically stapling cotton onto the edge of a hockey stick and dipping it in kerosene. Mike was really good about it. The flame didn't come anywhere near him, and I got off six to eight shots until the fire went out. We also set off the arena's fire alarm."

*Nassau Coliseum,
New York.
October 1980.*

►

ROBERTO LUONGO

Stanley Cup final Game 1.

*Rogers Arena,
Vancouver.
June 1, 2011.*

◂

HERB BROOKS

1980.

▸

MIKE BOSSY

*Nassau Coliseum,
New York.
1982-83 Season.*

◂

WAYNE GRETZKY & GORDIE HOWE

The Great One passes Mr. Hockey on the all-time points list.

*Northlands Coliseum, Edmonton.
October 15, 1989.*

▸

JOHN TAVARES

BB: "All these years shooting hockey and I didn't try in-camera multiple exposures until 2015."

*Nassau Coliseum, New York.
March 26, 2015.*

◂

RAY BOURQUE

*Nassau Coliseum,
New York.
October 1980.*

▸

RAY BOURQUE & JOE SAKIC

More than two decades after being a 19-year-old sophomore with the Bruins, Bourque finally realizes his Stanley Cup dream at 40 with the Avalanche.

*Pepsi Center,
Colorado.
June 9, 2001.*

CANADIAN NATIONAL WOMEN'S TEAM

BB: "About five months before the 2010 Winter Olympics, I flew to Vancouver to see what the arena looked like for shooting and for remote camera placement, and also to get some ideas of where I'd shoot from and where other photographers would be placed. Basically, I was coming up with a game plan. There was hockey going on at the time, including a practice for Canada's women's team. When they got into that beautiful symmetrical pattern, I quickly grabbed my camera and said, 'Oh, I've got to shoot this, this is awesome.' "

General Motors Place, Vancouver.
September 1, 2009.

ALEX OVECHKIN & T.J. OSHIE

Winter Olympics.

Bolshoy Ice Dome, Sochi, Russia.
February 15, 2014.

◀

SIDNEY CROSBY

*Wachovia Center,
Philadelphia.
October 14, 2005.*

▶

**DON CHERRY
& BLUE**

133

MIKE GARTNER

Nassau Coliseum, New York.

COLIN WHITE & GEORGE W. BUSH

The president has a laugh with White and the rest of the Stanley Cup champion Devils.

The White House, Washington, D.C. September 29, 2003.

◄

DANIEL & HENRIK SEDIN

All-Star Game.

*Scotiabank Place,
Ottawa.
January 29, 2012.*

►

SIDNEY CROSBY

*Joe Louis Arena,
Detroit.
June 12, 2009.*

MARIO LEMIEUX

Nassau Coliseum, New York. Late 1980s.

BRIAN STRAIT & DUSTIN BROWN

BB: "This image provides a glimpse of the shooting limitations of photographing the game these days as most photography is accomplished through a 4.5-inch x 5.5-inch portal."

Nassau Coliseum, New York. March 26, 2015.

JONAS HILLER

*Honda Center,
Anaheim.
January 12, 2011.*

BOBBY CLARKE

November 1983.

MARK MESSIER & KEITH ACTON

The Spectrum, Philadelphia. 1991-92 Season.

LANNY McDONALD & JOE MULLEN

BB: "I was photographing Mullen at a morning skate when McDonald came along and just jumped in and photobombed the shoot before anybody knew what a photobomb was."

Brendan Byrne Arena, New Jersey. 1980s.

◄

MARTIN BRODEUR

BB: "I never saw this one coming. A perfect reflection that became apparent when I looked through the images on the computer minutes later."

*Prudential Center,
New Jersey.
March 28, 2009.*

►

ALEX OVECHKIN

*Madison Square Garden,
New York.
October 12, 2007.*

JIM 'BEARCAT' MURRAY

BB: "Trainers are the hardest-working guys in hockey. They're at the arenas long before the players arrive and long after they leave – dragging equipment in the night before to set up for the players and then putting it all away after the game is over. Jim was one of hockey's best personalities and one of the greatest characters in the game."

*Nassau Coliseum,
New York.*

DENIS POTVIN & MARK MESSIER

BB: "Here's Potvin desperately trying to get Messier out of the crease, but he was a tough guy to move. I like the expressions in this image more than anything else, and the fact you've got two Hall of Famers together."

*Nassau Coliseum,
New York.
1980s.*

DYNAMIC DUO

Gretzky shovels the puck over to Lemieux who scores in double overtime to propel Canada to a 6-5 win in Game 2, evening the three-game final at 1-1. The Canadians would take the series in Game 3 with another 6-5 win over the Soviets two days later to capture the Canada Cup.

Copps Coliseum, Hamilton, Ont. September 13, 1987.

JESPER FAST

*Prudential Center,
New Jersey.
April 7, 2015.*

THE SUTTERS

Duane, Rich, father Louis, Ron and Brent.

*Vancouver.
1982.*

◄

TOM BARRASSO

*The Forum,
Montreal.
June 8, 1983.*

➤

GERRY CHEEVERS

*Nassau Coliseum,
New York.
1970s.*

GEORGE PARROS

Parros takes Lord Stanley's mug on a tour of Westminster Abbey prior to a game in London, England.

September 26, 2007.

GRETZKY & FRIENDS TOUR

Marty McSorley, Wayne Gretzky, Paul Coffey and Mark Messier with their fathers, Mr. Bill McSorley, Mr. Walter Gretzky, Mr. Jack Coffey and Mr. Doug Messier.

*Oslo, Norway.
December 1994.*

155

◁

**PAUL COFFEY,
MARK MESSIER
& WAYNE GRETZKY**

1982.

▶

CRAIG JANNEY

BB: "Janney was known as a thinking-man's player, hence the thinker pose."

*Nassau Coliseum,
New York.
November 1991.*

DOUG JARVIS

BB: "The NHL's iron man sets a record with his 964th consecutive game played. That's my assistant Brian Miller tucked inside the suit of armor."

November 1986.

KEN DRYDEN

Madison Square Garden, New York.

◀

DOUG GILMOUR

*Nassau Coliseum,
New York.
Mid-1980s.*

▶

**MIKE RICHTER &
JOHN VANBIESBROUCK**

BB: "This was taken when the two goalies were the super tandem 'VanRichterBrouck.' I cut the jersey in half to get the two-headed monster shot, and they squeezed into it to get a cover shot for The Hockey News."

*Rye Playland, N.Y.
January 1991.*

U.S. OLYMPIANS

Al Iafrate, David Jensen, Ed Olczyk (top) and Lou Vairo, Pat LaFontaine (bottom).

Sarajevo Winter Olympics. 1984.

MARTIN BRODEUR

Prudential Center, New Jersey. April 16, 2010.

◂

RAT ATTACK

In a newfound tradition, Panthers fans shower the ice with plastic rats during Game 3 of the Stanley Cup final against the Avalanche.

*Miami Arena,
Florida.
June 8, 1996.*

▸

**LUC ROBITAILLE
& JIMMY CARSON**

March 1988.

◄

MIKE RICHARDS & RICK DIPIETRO

*Nassau Coliseum,
New York.
March 4, 2006.*

►

SIDNEY CROSBY & ZDENO CHARA

Eastern Conference final Game 1.

*Consol Energy Center,
Pittsburgh.
June 1, 2013.*

167

◀

AL ARBOUR

BB: "This is after an overnight flight from Vancouver following the Islanders' third straight Stanley Cup. A bunch of fans were waiting on the other side of the fence from the runway to greet the team. There was this freestanding, ancient staircase on the tarmac, so coach Al Arbour and a couple players took turns going up it and acknowledging the fans."

*LaGuardia Airport,
Flushing, N.Y.
May 17, 1982.*

▶

BRENDAN WITT

*Nassau Coliseum,
New York.
October 8, 2008.*

◄

WENDEL CLARK

The Maple Leafs take Clark first overall in the NHL draft.

Metro Toronto Convention Centre, Toronto, Ont.
June 15, 1985.

►

ILYA KOVALCHUK

Prudential Center, New Jersey.
March 4, 2011.

RYAN MILLER & SIDNEY CROSBY

BB: "The rule for the Vancouver Games was that any photographers going onto the ice after the game needed to be lined up in the Zamboni corner midway through the third period. That meant for the last 10 minutes of regulation and all of overtime I was either standing or kneeling among all the photographers more than 30 feet away from the ice. I still had remote cameras in the rafters, so I would peek through the back of the stands, watch the game on the scoreboard and push the button for the remote at any point I thought there might be a shot that could be a game-winning goal or a great save. It wasn't until long after the game had ended that I saw the editors had found this gem of Crosby's golden goal in overtime amongst all the images on my remote camera."

*Canada Hockey Place,
Vancouver.
February 28, 2010.*

EVGENI NABOKOV & JAROMIR JAGR

BB: "When you're photographing players, either waiting for a faceoff or after colliding into each other, sometimes you see them talking to each other. It's always interesting to see which players gently pass comments between each other. It makes you wonder what they're saying...or whether I would be able to print those comments here."

Winter Olympics.

*Canada Hockey Place,
Vancouver.
February 21, 2010.*

CHRIS KONTOS

Kontos scores four goals for the Lightning in the franchise's first game ever.

*Expo Hall,
Tampa Bay.
October 7, 1992.*

NEW YORK ISLANDERS

The Isles hold their first practice at their new digs for 2015-16.

*Barclays Center,
New York.
September 12, 2013.*

175

PETER FORSBERG

*Wachovia Center,
Philadelphia.
August 15, 2005.*

S.J. SHARKIE

*HP Pavilion,
San Jose.
January 7, 2012.*

◀

SIDNEY CROSBY

*Air Canada Centre,
Toronto.
November 14, 2014.*

▶

ERIC LINDROS

'The Big E' hamming it up on the eve of being drafted first overall by the Nordiques.

*Buffalo, N.Y.
June 21, 1991.*

CHRIS SIMON

BB: "This is actually bad lighting that turned into an engaging photograph. Simon's glove is blocking part of the studio light, but the shadow cast across his face leads you directly to his eyes."

*Nassau Coliseum,
New York.
September 14, 2006.*

ANDERS HEDBERG & ULF NILSSON

BB: "The two star Swedes were shot on the ice, which was put in just for the photo op when the players were signed that summer."

*Madison Square Garden,
New York.
1978.*

> **JOHN VANBIESBROUCK**
>
> Commemorating his 300th NHL win.
>
> *Nassau Coliseum, New York.
> December 27, 1997.*

> **WAYNE GRETZKY
> & MARK MESSIER**
>
> Friends become enemies as The Great One returns to Edmonton following The Trade.
>
> *Northlands Coliseum, Edmonton.
> Late 1980s.*

◄

**ALEX OVECHKIN
& SCOTT GOMEZ**

*Madison Square Garden,
New York.
April 26, 2009.*

▶

**PETER, MARIAN
& ANTON STASTNY**

The Czech brothers keep it all in the Nordiques family in the early '80s.

October 1981.

DAN BOUCHARD

BB: "The funniest part of this shoot was that we gave Bouchard a puck and asked him to toss the puck into the air while looking at the camera. He was one of the best goalies in the league at the time, but he dropped eight out of ten tosses. My assistant, Brian Winkler, and I couldn't wait for him to leave the room, because when he did we doubled over in laughter."

March 1981.

GOLDIE HAWN, MARK MESSIER & BURT REYNOLDS

*Memorial Auditorium,
Buffalo.
1982.*

MARIO LEMIEUX

'Super Mario' celebrates his 500th NHL goal.

Nassau Coliseum, New York. October 26, 1995.

◂

BILLY SMITH

*Woodbury, N.Y.
October 1983.*

▸

**ALEX OVECHKIN
& SIDNEY CROSBY**

'Ovie' greets 'Sid' after the Penguins eliminate the Capitals in Game 7 of the Western Conference semifinal.

*Verizon Center,
Washington.
May 13, 2009.*

◀

**TROY BODIE
& STEVE OTT**

*American Airlines Center,
Dallas.
October 26, 2010.*

▶

**WILLIE HUBER &
REIJO RUOTSALAINEN**

*Madison Square Garden,
New York.
March 1986.*

ACTOR JOHN CANDY

New York, N.Y.
1985.

FLAMES & ISLANDERS

Nassau Coliseum,
New York.
December 29, 2011.

◄

NICKLAS BACKSTROM & ALEX OVECHKIN

Madison Square Garden, New York.
November 17, 2009.

►

SCOTTY BOWMAN & BRETT HULL

'The Brain' and 'The Golden Brett' celebrate their ninth and second Stanley Cups, respectively.

Joe Louis Arena, Detroit.
June 13, 2002.

JONATHAN TOEWS & DYLAN REESE

*Nassau Coliseum,
New York.
December 8, 2011.*

RICK DiPIETRO

Nassau Coliseum, New York. December 29, 2010.

◂

WAYNE GRETZKY

BB: "The Great One's 77th goal to beat Phil Esposito's single-season record for goals. This shot has always been a top seller. It's interesting and quite telling, because it's not really a great shot, but it's a moment that has a place in history."

*Memorial Auditorium,
Buffalo.
February 24, 1982.*

▸

MARIO LEMIEUX

Stanley Cup final Game 1.

*Civic Center,
Pittsburgh.
May 26, 1992.*

ZACH PARISE

BB: "Over the course of an Olympics, emotions run so high you can always count on getting shots with feeling. In a hockey photograph, the face always tells the story. It's not about the puck and the sticks raised as much as it is seeing the players' faces and body language, both the jubilation and the dejection."

Preliminary round game between Canada and the U.S. at the Winter Olympics.

Canada Hockey Place, Vancouver. February 21, 2010.

JONAS HOLOS & ANDREAS NODL

Winter Olympics.

Bolshoy Ice Dome, Sochi, Russia. February 16, 2014.

◀

MARK MESSIER

November 1991.

▶

ALEX OVECHKIN

*Madison Square Garden,
New York.
April 28, 2012.*

◂

**VALTTERI FILPPULA,
MARC-ANDRE FLEURY
& KRIS LETANG**

Stanley Cup final Game 2.

*Joe Louis Arena,
Detroit.
May 26, 2008.*

▸

PAVEL BURE

*Madison Square Garden,
New York.
March 19, 2002.*

◀

**MARK STREIT &
EVGENI NABOKOV**

*Nassau Coliseum,
New York.
March 9, 2013.*

▶

PHIL ESPOSITO

*World Trade Center, N.Y.
September 1986.*

MIKE BOSSY & BRYAN TROTTIER

Nassau Coliseum, New York.
1980s.

ADAM HENRIQUE

The Devils eliminate the Rangers after Henrique's overtime goal in Game 6 of the Eastern Conference final.

Prudential Center, New Jersey.
May 25, 2012.

211

◁

TYLER SEGUIN
& MILAN LUCIC

BB: "Sometimes the conversion of a photo from color to black and white enhances the feeling and provides for a more compelling image."

Eastern Conference semifinal Game 3.

Madison Square Garden, New York.
May 21, 2013.

▷

BUTCH GORING
& DENIS POTVIN

The Islanders bring home the franchise's first of four straight Stanley Cups.

Nassau Coliseum, New York.
May 24, 1980.

◀

NEW YORK RANGERS

*Rye, N.Y.
1993-94 Season.*

▶

**SIDNEY CROSBY
& JAKE GARDINER**

*Air Canada Centre,
Toronto.
November 14, 2014.*

215

◀

GLEN WESLEY

Wesley celebrates with his family after winning his first and only Stanley Cup at 37 years old.

*RBC Center,
Carolina.
June 19, 2006.*

▶

NEW YORK RANGERS

The Blueshirts go through aerobics exercises on the boardwalk beside the team's practice arena.

*Rye, N.Y.
September 1982.*

MATS ZUCCARELLO

Coors Light Stadium Series.

*Yankee Stadium, N.Y.
January 26, 2014.*

MAREK ZIDLICKY & BRIAN BOYLE

Coors Light Stadium Series.

*Yankee Stadium, N.Y.
January 26, 2014.*

◁

MARK MESSIER

BB: "When Messier picked up the Cup for the sixth time, you could see the joy all over his face. It's one of those infectious smiles where you look at the picture and you almost smile right back at it. You just can't help it. He'd won five Cups before with Edmonton, but with New York it was almost like he'd won it for the first time."

*Madison Square Garden,
New York.
June 14, 1994.*

▷

**TRAVIS HAMONIC
& NICK BJUGSTAD**

*Nassau Coliseum,
New York.
April 1, 2014.*

◁

YVAN COURNOYER

It never gets old for Cournoyer as he celebrates his seventh Stanley Cup, with three more still to come before calling it a career.

The Spectrum, Philadelphia. May 16, 1976.

▷

CHRIS KREIDER

Eastern Conference final Game 1.

Bell Centre, Montreal. May 17, 2014.

SIDNEY CROSBY & CHRIS KREIDER

Atlantic Division final Game 4.

*Madison Square Garden, New York.
May 7, 2014.*

DENIS POTVIN

Islanders fans relive the team's glory years from the early '80s with their former captain.

*Nassau Coliseum, New York.
March 2, 2008.*

JAROMIR JAGR & DAVID CLARKSON

*Prudential Center,
New Jersey.
February 1, 2008.*

BILLY SMITH

*Nassau Coliseum,
New York.
October 1983.*

ZDENO CHARA

The scariest man in hockey is frightening even when expressing pure joy after winning the Stanley Cup.

*Rogers Arena, Vancouver.
June 15, 2011.*

BRYAN TROTTIER

Seconds before the Islanders sweep the Oilers to win their fourth straight Stanley Cup.

*Nassau Coliseum, New York.
May 17, 1983.*

DUSTIN BYFUGLIEN

'Big Buff' celebrates the Blackhawks' first Stanley Cup since 1961 thanks to Kane's double-overtime winner to beat the Flyers in Game 6 of the final.

*Wachovia Center, Philadelphia.
June 9, 2010.*

ANDREW LADD, PATRICK SHARP, NICK BOYNTON & PATRICK KANE

*Wachovia Center, Philadelphia.
June 9, 2010.*

◀

ROB SCUDERI

Scuderi tastes Stanley Cup glory for the second time in his career (Penguins in 2009) and his first with the Kings.

*Staples Center,
Los Angeles.
June 11, 2012.*

▶

BERNIE NICHOLLS

*Great Western Forum,
Los Angeles.
October 1989.*

◀

WAYNE GRETZKY

BB: "This was in the waning days of the World Hockey Association, and it's by far one of my most popular images. Wayne's reputation preceded him from the time he was a small boy, so I made a special trip to Springfield where the Oilers were visiting the New England Whalers. Edmonton was set to join the NHL the following year, so my sole purpose of going up for that game was to make sure I had some images of Wayne as an 18-year-old. When I shot this photo, he was looking at the hordes of media coming into the room, and I was lucky enough to have him right in front of me. It shows how young he is. He looks so small and scrawny, yet he went on to break so many scoring records."

Springfield, Mass.
April 1979.

▶

MARK MESSIER

Madison Square Garden,
New York.
1990s.

HALEY IRWIN & MEGHAN AGOSTA

BB: "It's so great to see players unwind after everything they went through. Here Irwin and Agosta are savoring their win over the U.S. in the final at the Winter Olympics. They won a gold medal, so they earned the right to celebrate their way, and I liked the empty arena behind them."

Canada Hockey Place, Vancouver.
February 25, 2010.

CANADIAN NATIONAL MEN'S TEAM

BB: "This is what we call the Hail Mary shot. I put a camera with a fish-eye lens at the end of a long monopod, sort of like a professional selfie-stick, which allowed me to raise it above the fans. I just guessed at the framing and hoped for the best while pushing a remote triggering button."

Preliminary round game between Canada and the U.S. at the Winter Olympics.

Canada Hockey Place, Vancouver.
February 21, 2010.

TIE DOMI

With players from local youth leagues.

RIGA2000 Arena, Riga, Latvia. December 8, 2004.

MARC BERGEVIN

BB: "Bergevin was coaching a team of NHL players, including Domi, on the IMG/Primus Worldstars exhibition tour during the 2004-05 lockout, and he liked keeping the guys loose. Whether he was lying down inside a hockey bag and being carried through the room or dressing like some sort of emperor, he kept the guys entertained."

Oslo Spektrum, Oslo, Norway. December 21, 2004.

IAN LAPERRIERE & RHETT WARRENER

BB: "While on the Worldstars tour, we stopped for a game in Katowice, Poland, which is about an hour bus ride to Auschwitz. A bunch of the media and some of the players visited the former Nazi concentration camp."

*Auschwitz, Poland.
December 22, 2004.*

GORDIE HOWE

*Hartford Civic Center,
Hartford, Conn.
April 11, 1980.*

◂

PAT LAFONTAINE

BB: "Between periods of the Easter Epic, I had to walk around to other photographers and bum rolls of film because I was so close to being out. By the fourth overtime, I was only taking a single photo each time a guy would take a shot."

LaFontaine scores in quadruple overtime as the Islanders eliminate the Capitals in Game 7 of the Patrick Division semifinal.

*Capital Center,
Washington.
April 18, 1987.*

▸

PATRICK ROY

A rookie Roy savors his first Stanley Cup with the Canadiens.

*Olympic Saddledome,
Calgary.
May 24, 1986.*

LANNY McDONALD

BB: "It's always tough to sell an image of a player with his eyes closed, except in this instance. At 36 years old, McDonald finally realizes his lifelong goal of winning the Stanley Cup."

*The Forum,
Montreal.
May 25, 1989.*

JOHN TRIPP

BB: "Seems kind of funny to me that after Olympic handshakes some players immediately wipe their hands off on the ice."

*Canada Hockey Place,
Vancouver.
February 20, 2010.*

245

BEN BISHOP

Eastern Conference final Game 1.

*Madison Square Garden, New York.
May 16, 2015.*

MARIO LEMIEUX & JAROMIR JAGR

BB: "This was done after the Penguins won their second straight Cup, hence the back-to-back pose."

1992.

◂

SANTA CLAUS

A New York Islanders promotional event featured free tickets to anyone arriving in a Santa Claus costume.

*Nassau Coliseum,
New York.
December 23, 2003.*

▸

ERIC GELINAS & DAVID MOSS

BB: "I started playing around with a camera that records infrared light and came away with some very strange images."

*Prudential Center,
New Jersey.
March 27, 2014.*

◄

WAYNE STEPHENSON

*Madison Square Garden,
New York.
1980.*

▶

VINCENT LECAVALIER

Lecavalier takes a piece of advertising with him after being checked into the boards.

*Nassau Coliseum,
New York.
December 9, 2003.*

◀

STEPHEN GIONTA
& RYAN CARTER

BB: "This frame captured just part of another photographer's strobe light blast. Their 1/1000th of a second burst didn't line up with 1/800th of a second shutter speed. That doesn't happen often."

*Madison Square Garden,
New York.
May 23, 2012.*

▶

BOB GAINEY

BB: "I was doing work for The Hockey News in the late 1970s, and I told them I was willing to go to Montreal for the Stanley Cup final. I wasn't prepared at the end of the game, because I couldn't figure out how to get on the ice. Another photographer and I ran around the rink in one direction but got stopped by the security guards. We tried running around in the other direction, and at some point he and I split off in different ways. He was able to get on the ice, but I wasn't. Hyperventilating at the time, I jumped onto some chairs – luckily back then the glass was low – with the help of a couple fans who steadied me. All I was able to get at the time was the back of Bob Gainey being picked up on his teammates' shoulders. As it turns out, this photo is one of my best-selling images of all-time. It shows the glory of winning the Stanley Cup, and how it's a team effort, with all the hands holding Gainey up. It became a symbol for the team sport that hockey is."

*The Forum,
Montreal.
May 21, 1979.*

THE BACKWORD

BY BRUCE BENNETT

Okay, so The Great One graciously accepted my request to do "The Foreword." Through my own warped logic, then, I'll take "The Backword." What would you have done? And to have Gretzky write the foreword and Martin Brodeur "The Big Picture" I think I'm pretty well surrounded by the superstars I admire most.

What you've just paged through is a compilation of images documenting snippets of hockey history. Freezing a moment in time can preserve a treasured, historic and remarkable moment in the legacy of the sport we all love. This is something I've dedicated my adult life to, and it couldn't have turned out any better.

My story starts in 1974 when, as a high school student, I sent a few black-and-white images to the editor and publisher of The Hockey News, Ken McKenzie, wondering whether he was looking for photographs. After some back and forth, Ken offered $4 per photo plus a press pass. I started covering games at Madison Square Garden and Nassau Coliseum that fall.

In the beginning…there was film. Specifically, Kodak Tri-X 400 ASA black-and-white negative film. Three rolls – one for each period – were strapped to the inside flap of a small black leatherette camera bag, and resting inside was a simple setup: one Yashica 35mm camera with an Acura 135mm 2.8 lens.

After shooting games, I'd return home late to my parents' home 30 miles east of New York City in the suburban community of Levittown, N.Y. In my bedroom, I'd gently place my bag at the foot of the bed and unzip it to remove the film. The pungent smell of cigarette smoke that filled MSG in those days would hit me in the face as I placed the canisters on the desk for processing the next day.

A few short years later, the Yashica was replaced with an Argus-Cosina camera and a Vivitar 85-205mm 3.8 lens, and later by Nikon cameras with a similar focal length Vivitar lens along with the popular industry standard Nikkor 180mm f/2.8. Twenty-five years later, a switch to Canon, and then on to Canon digital cameras starting in 2001.

I started my business in 1973 as "Hockey Shots, Etc." and it quickly morphed into Bruce Bennett Studios (BBS). In 1980 I hired my first employee, Brian Winkler, and at the height of the hockey photo business (which coincided with the hockey trading card boom in the early 1990s) our company had 15 employees with more than a dozen contributing photographers. After 30 years, I sold BBS to Getty Images, where I continue to shoot and direct the company's hockey coverage.

Over the years, there had been a logical transition from black and white negative, to color negative, to color slides and then on to digital. As the industry evolved rapidly, photographers either adapted to the digital revolution or perished. The fact I am a computer geek helped me survive and change as the industry changed around me. No step was taken until the appropriate time.

Where we are headed photographically is open for speculation, but I'm thinking my next book may actually be a video.

Image selection for this project was a monumental task. Going from more than two million photographs to 246 was hard enough, but other considerations made the process even more difficult. If an image wasn't great but captured an historic moment, I had to decide whether to keep it for its historical significance, even if it was sub-par technically or the product of bad slide duplicates or marginal quality digital scans where the original images had disappeared.

Where do I even begin to say thanks for my lifetime in hockey?

I have often joked that home is the place I stop at between hockey games. On April 8, 2014, I shot my 5,000th game. When the enormity of that number sunk in, I realized the better part of my life had been spent in arenas around the world. So with all my heart, this book is for my wife, Betty Ann, for her endless support and selfless pride in my work. She spent countless nights alone (somewhere north of 5,000), raising the kids or being the "single parent" going out with our married friends while I was traipsing around the world.

To my kids, Melanie and Max, who also were very understanding about my long absences and always supportive and proud of the work I have accomplished. After all, I was the cool dad, as many of their friends had my posters on their walls. I'm pleased both kids have taken an interest in photography.

To my parents, for their endless support, and for allowing me to destroy the top of their washing machine with corrosive photo chemicals during my darkroom days, just as a young Sidney Crosby destroyed his parents' washing machine by shooting pucks into it for practice.

To Randy Freider, who started me in photography, and to Joe DiMaggio (not the baseball player) and Joann Kalish, who mentored me. To friends now lost, John Martin of Worldsport, and photographers Lou Capozzola, Denis Brodeur and David Bier. All were inspirations to me. To the public relations people with the league and teams, including the late great John Halligan, who have allowed me to make the NHL my playground.

My sincerest gratitude to Jason Kay, who helped ensure this project came together. Special thanks to the book's art director Erika Vanderveer for making me look good. This couldn't have happened without her incredible talent and love of images. And also to Ronnie Shuker for his editorial guidance and attention to detail.

To the core BBS employees, especially my studio director Brian Winkler. And the backbones: Jim McIsaac, John Giamundo, Marco Campanelli, Glenn Levy, Joe Lozito, Jim Leary, Scott Levy and Lisa Meyer, and all the photographers who worked with BBS during its 30 years.

To my Getty Images family, including chairman Jonathan Klein, Peter Orlowsky, Ken Mainardis and Jason Sundberg. Most importantly, thanks to the always supportive Travis Lindquist, and to Carmin Romanelli, not only for his guidance and assistance on this project,

but more so for his continual support and the wealth of knowledge he has so generously shared with me during my time at the company.

To the players of the NHL and leagues everywhere who allowed me to capture their unique talents and record them for posterity. And also for their sense of humor and down to earth mentality that set them apart from other athletes.

Thanks to Martin Brodeur, who I was fortunate enough to shoot so often as the New Jersey Devil's team photographer. His late father, Denis, who I knew for 40 years, was one of hockey's best photographers. Together they are two of the game's all-time greats.

And of course, thanks to The Great One, Wayne Gretzky. The timing of my career was, for the most part, parallel to his playing days. I consider it a privilege to have had him in my camera's view for so many historic events.

I have made so many friends in this industry, too many to even mention a small percentile, so I'll provide my age-old response. Whenever friends would mention they'd be watching the Stanley Cup on-ice festivities to catch a glimpse of me, I'd tell them to look for me pulling on my right ear – that would be my way of saying "hi" right back. So to all, I'm tugging my right ear right now…

BRUCE BENNETT

I always thought that when I was done shooting games I'd be buried at center ice in Nassau Coliseum, but I guess the crease would be an acceptable resting place, too. So here I lie, with the camera mounted in the rafters above me, remote trigger in hand. But there are many more games in my future, and each and every one presents a unique challenge – capturing this wonderful sport by freezing a frame for the next book.